HUMAN/NATURE

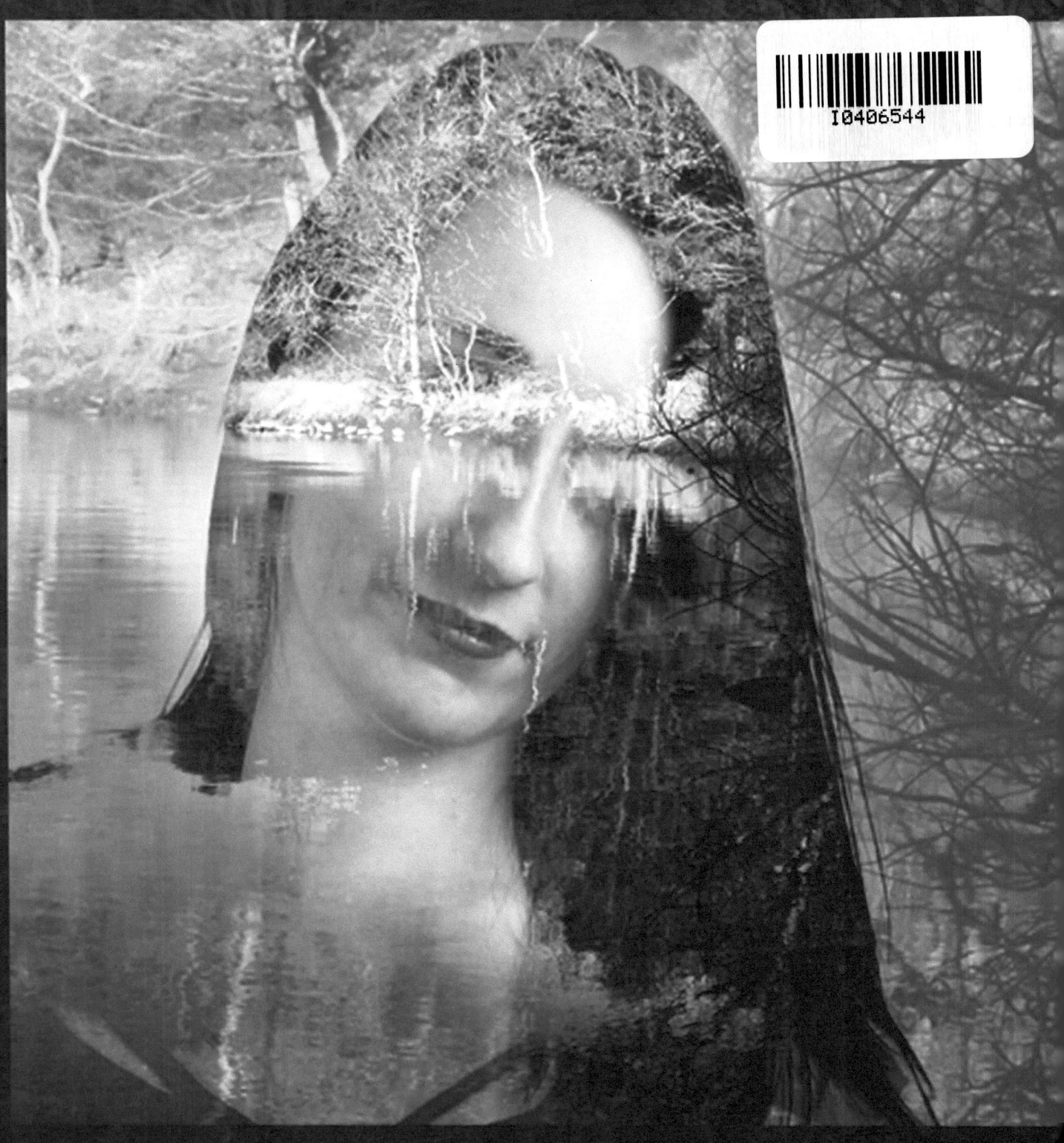

Megan Wilson and Alex Nolan

HUMAN/NATURE

Photographs by Megan Wilson

Poetry by Alex Nolan

Copyright © 2016 by Megan Wilson and Alex Nolan

All rights reserved. No part of this publication may be reproduced, distributed, or transmitted in any form or by any means, including photocopying, recording, or other electronic or mechanical methods, without the prior written permission of the publisher, except in the case of brief quotations embodied in critical reviews and certain other noncommercial uses permitted by copyright law.

Foreword

Megan Wilson and Alex Nolan's *Human/Nature* is a multi-platform collaboration of photography and poetry. It reflects upon the metaphysical relationship between nature and humanity, depicting people submerged within their natural surroundings.

The photographic works, created by Wilson aim to unearth the core of our metaphysical relationship with nature, and as such revolve around the themes and ideas suggested by Romantic poetry. The act of discovery – how engagement with nature leads to growth and knowledge, how encounters in nature comment on the human condition, dramatic struggles occurring within the changing natural world, and lastly, how self-discovery can happen through exploring nature.

Nolan later came on board as a creative collaborator, endeavouring to move beyond the initial inspiration of the Romantics, and create his own poetic responses to the theme. Each individual art work is accompanied by a poem responding directly to the image.

What the works aim to do is open up new channels of thought. Lead someone down a forested path and make them look at how they relate to nature in a new way. After all, the natural world is all around us: we all have a relationship with it.

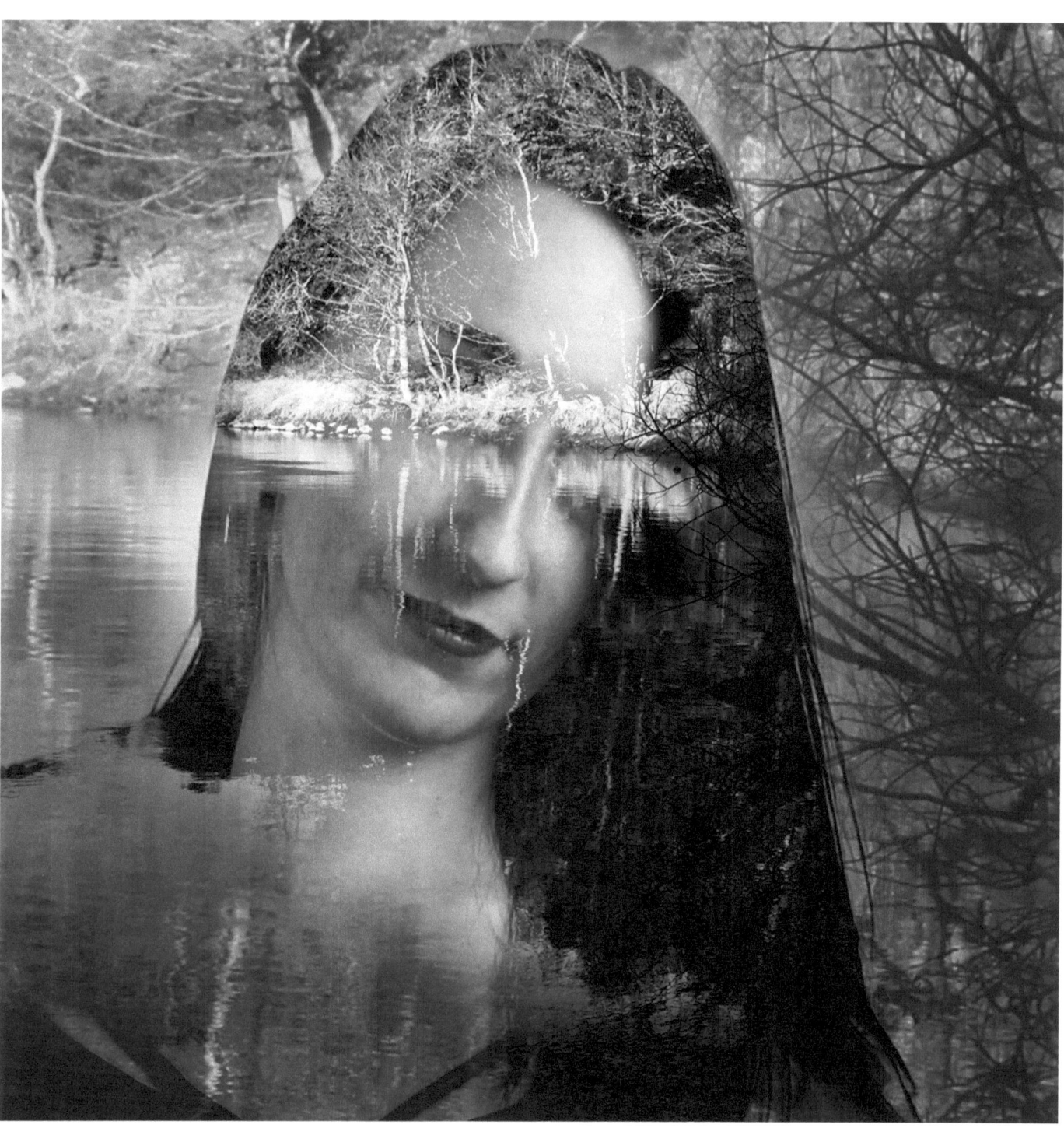

Ripples on Water

Does the misted dawn remember
the smile that traced your lips?
Does the flowing river catch a tear
and care for how you weep?
Does the forest fall in love,
when we kiss beneath the boughs?
Or is the Earth a background player,
that doesn't make a sound?

Our memories here recorded,
but ripples on the water.
Seasons trickle onward,
from winter to verdant daughter.
Regality from golden leaves,
and flowers in their sunburst splendour,
we are but peasants in her royal court,
that history shall scarce remember.

Yet when the ice draws in
and the leaves are last month's jewels,
your eyes reflect the flowing brook
and I question what I feel.
Perhaps this place is not ours
to carve a past among the banks,
and never shall we be the fruit
held upon the swaying branch.
but at times there is a chance
our romance can tangle up
with nature's ever growing heart
to dance among her roots.

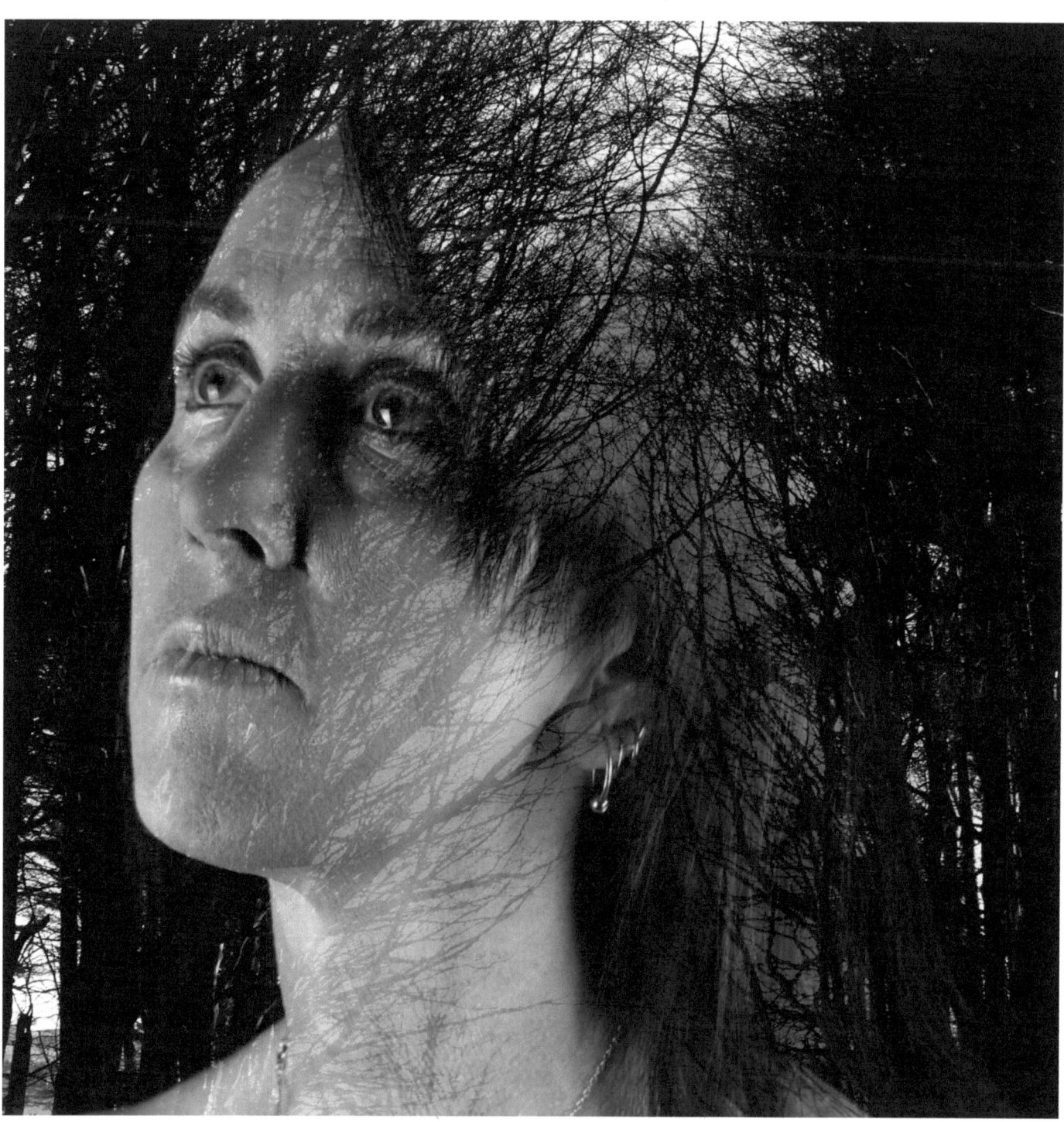

<u>Pains</u>

The forests here claw at the grey skies,
grasping at that vast expanse.
Branches tremble when birds take flight:
the wooden spider-web disturbed.

Click. Click.
"Every single tree."
I hold my breath.
I can see the fight for control: the quivering
of your hands.
Camera raised, your lens talks.
This wicked wood argues back.
Roots that tangle, crows that shriek
and heckle.
"You'll be right here. Every single tree."
Not your mantra, but your spell.

Conifers, in rows. Polite as can be,
they escort the tarmac road to the cul-de-sac.
They whisper in the breeze, sometimes
gossip when a tabby squeezes by.

Stones pump through my veins.
Thud after painful *thud*.
The birds still sing,
chirping domesticated melodies on fences
and hedgerows.
"Every single tree."
Tan bricks, and white window
panes.
Dog walking, hopscotch, washing lines, streetlamps and...
"You'll be right here."
I press my fingers to my temples. "Every single tree."

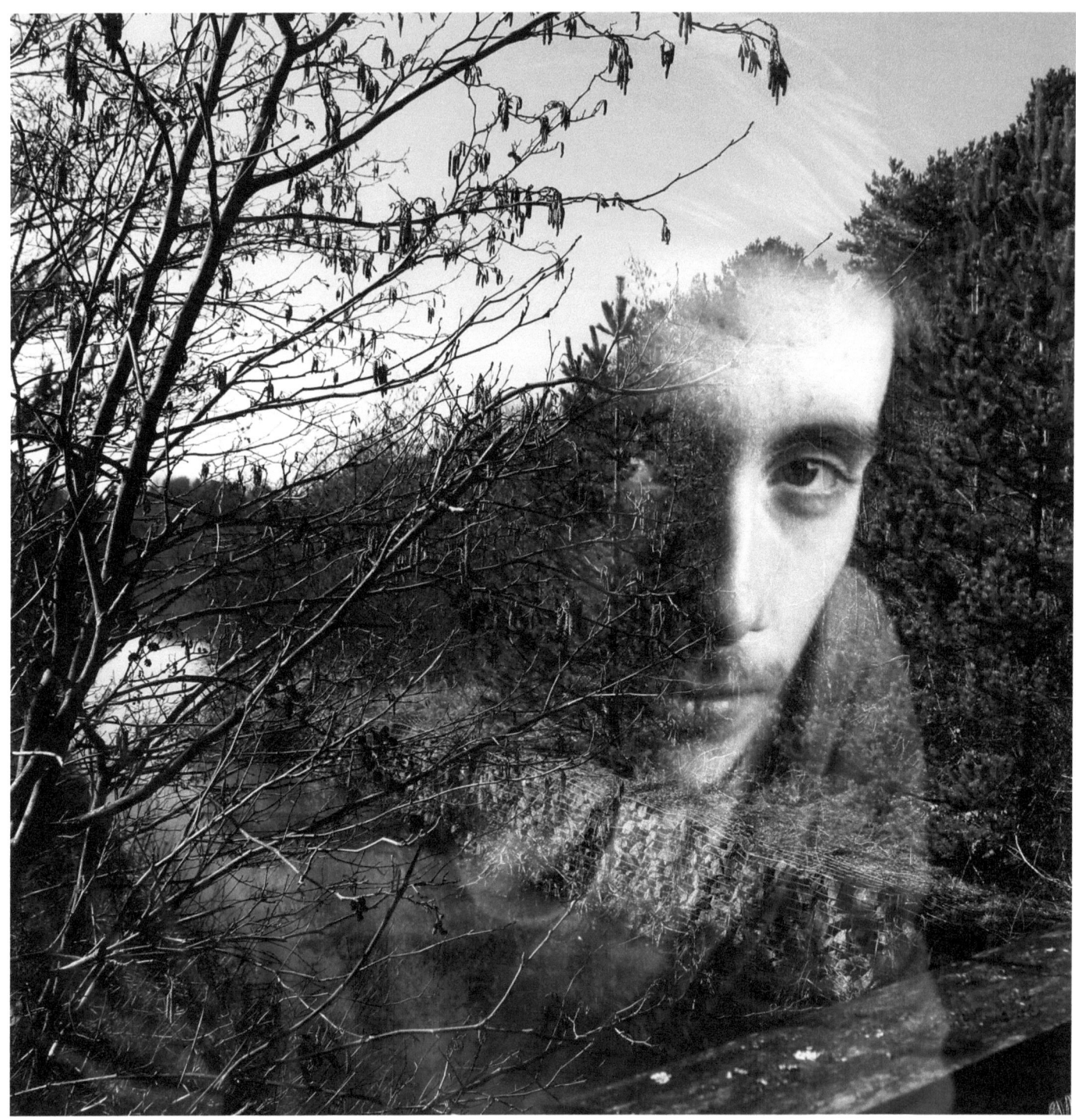

Push

Borderline:
where the water meets the land.
Where the sea meets the sand.
Where our towns push at the edge,
where the merge is more... boxy privet hedge.

We fight and we scream, 'this we must save',
and I bet that she'll thank us, for being that brave.
Our impact so grand, the balance tilts on us,
get over it.
We're spoiling it.
We won't be missed.

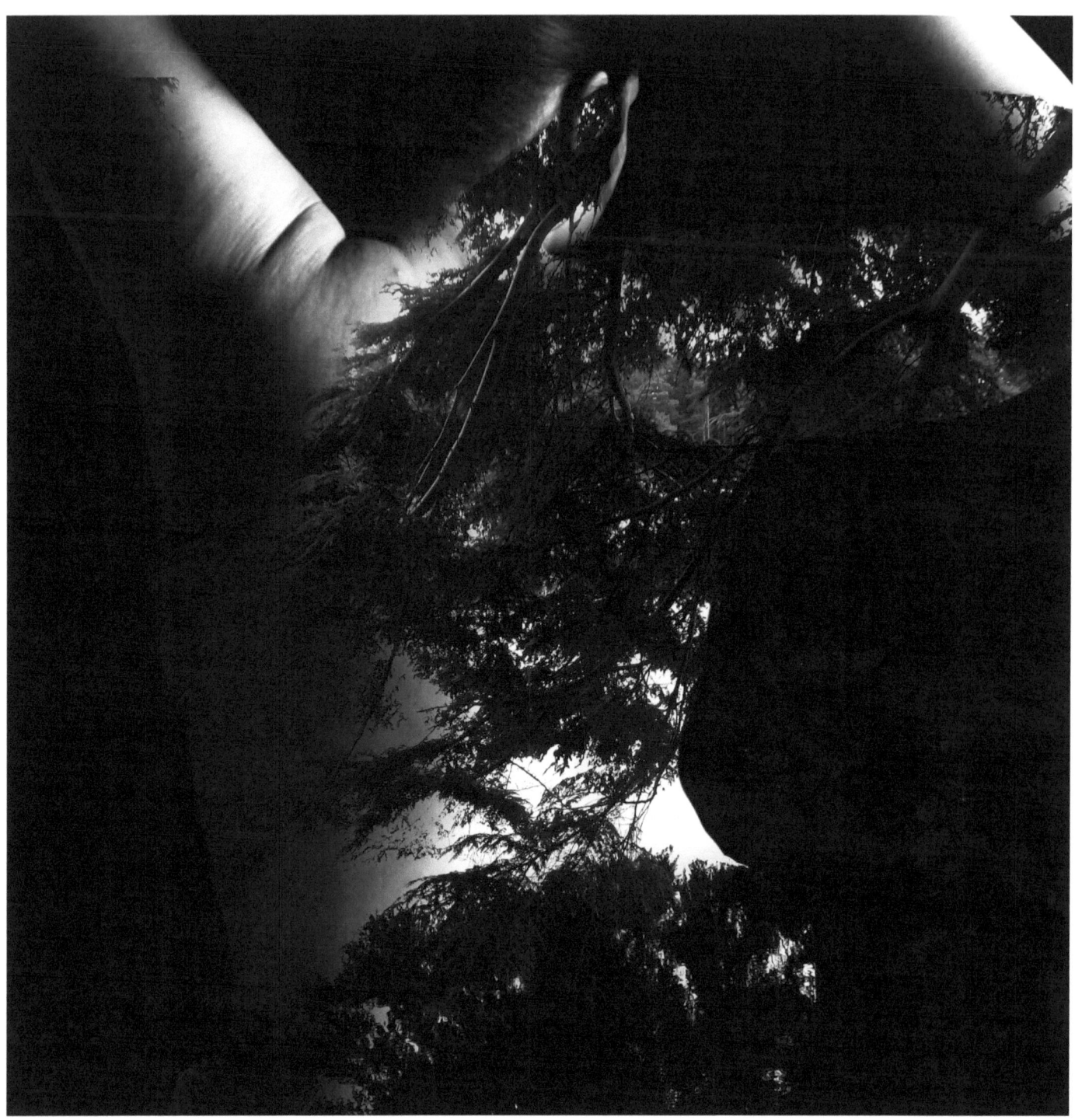

Unearth

Learn from you,
that is my choice.
Proud, tall, far-branching –
no 'quiet voice'.
Unearth my heart,
and lay roots anew,
blossom forth in bright colour,
take *that* bark and chew.

Forest as my teacher,
my witness and friend,
I will grow like the oak
and no longer bend.

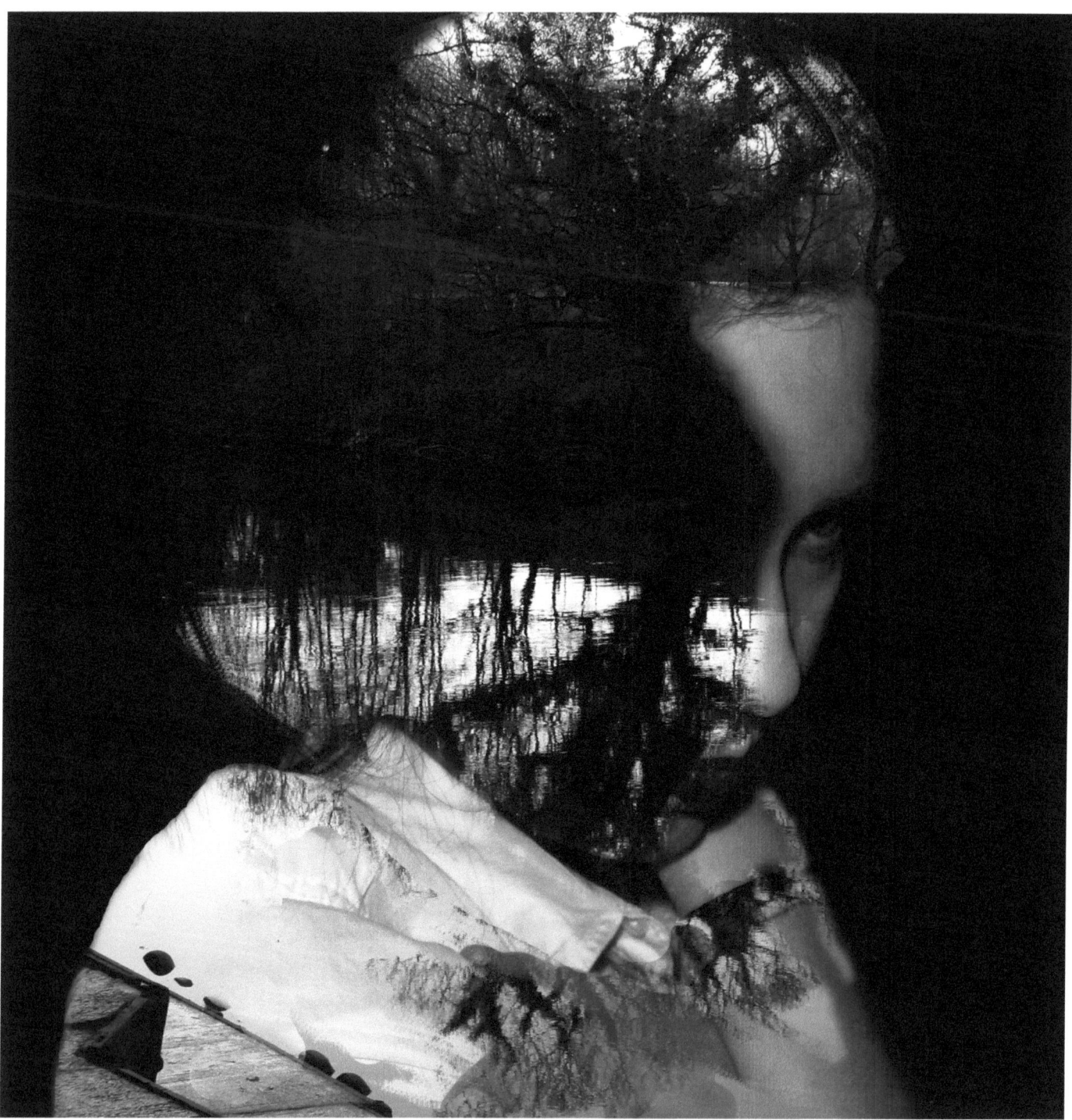

Mirror

Nature, our mother,
is it too much to ask,
for you to be
a truer mirror to me?
To see
my eyes in clear blue pools and
my lips in deep red berries?

With the grace of a swan,
and a step feather-light,
could I dance through this world,
and be butterfly-bright?

Allow me a measure of your splendour,
to be something more,
a wild swirling mystery,
not a plain unseen bore.
Just one song.
That's all I need.
Nothing else, nothing more:
it's all I plead.

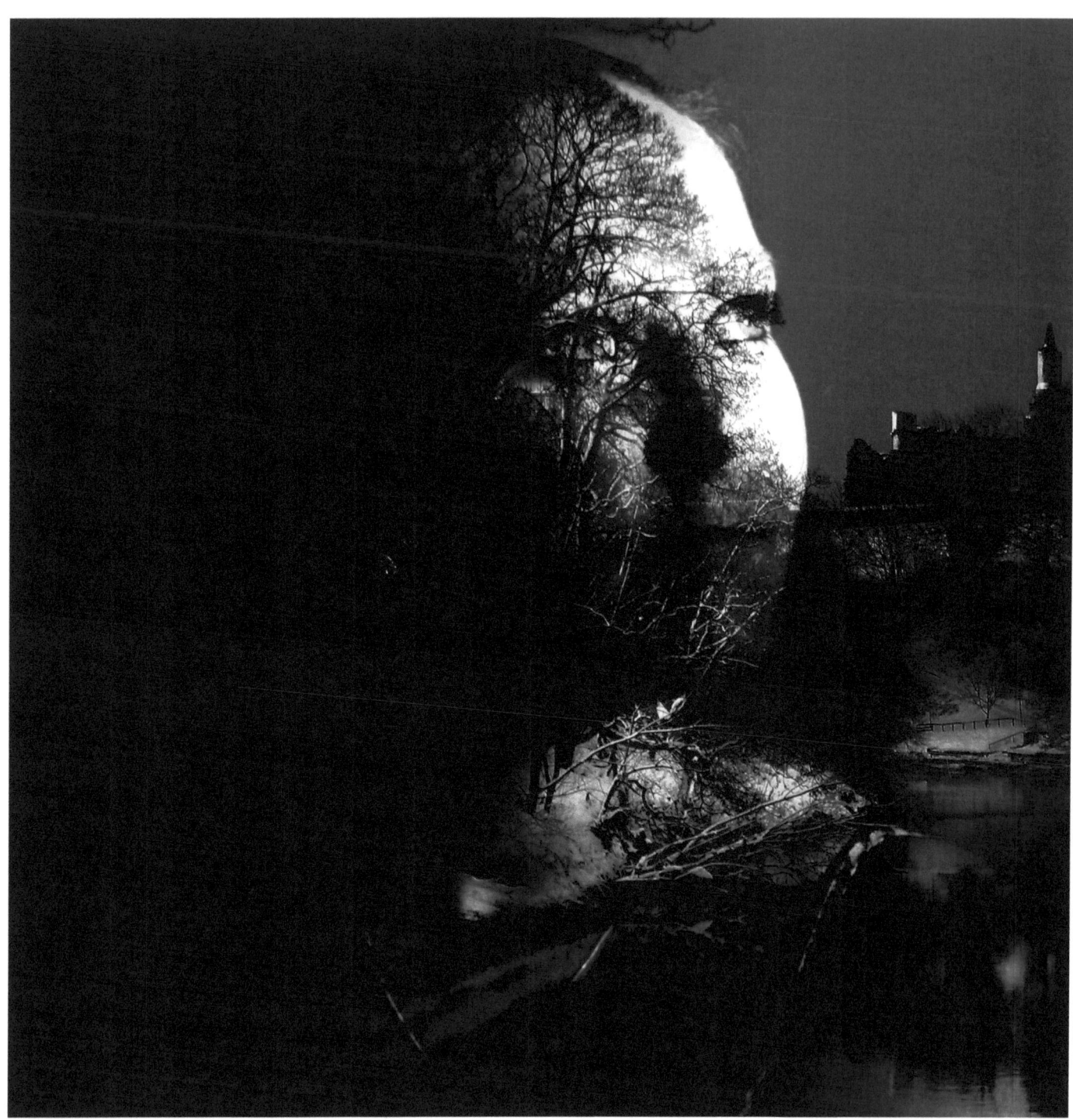

Soon After

Crush, crunch, crush.
I remember the colours that day.
White – the snow was freshly lain.
River was dark, almost black.
Brown tree limbs laced out across the grey cotton sky.
Colours.

Onwards, across the fields.

Crush, crunch, crush.
Boot prints in the snow.
Gone by next snowfall.
Our smallest impression on the world,
I remember thinking that.
The smokestacks were over the hill,
further off then. Puffs of black curling over the horizon.

Over bridges, across the meadows.

Crush, crunch, crush.
Ice melted in my boots, the water pooled.
Pine needles made
a nest of my a hair.
Pieces of everything had determined they would follow me
that day.

Through the forest, to the clearing.

Crush, crunch, crush.
My quiet space. A circle among the trees.
The place where I may breathe,
forget,
and rest.

And back to home.

The last walk I took there.
My sight faded soon after.
But
I keep pine needles in a jar
and
always press
my boots into fresh snow.
Crush, crunch, crush.

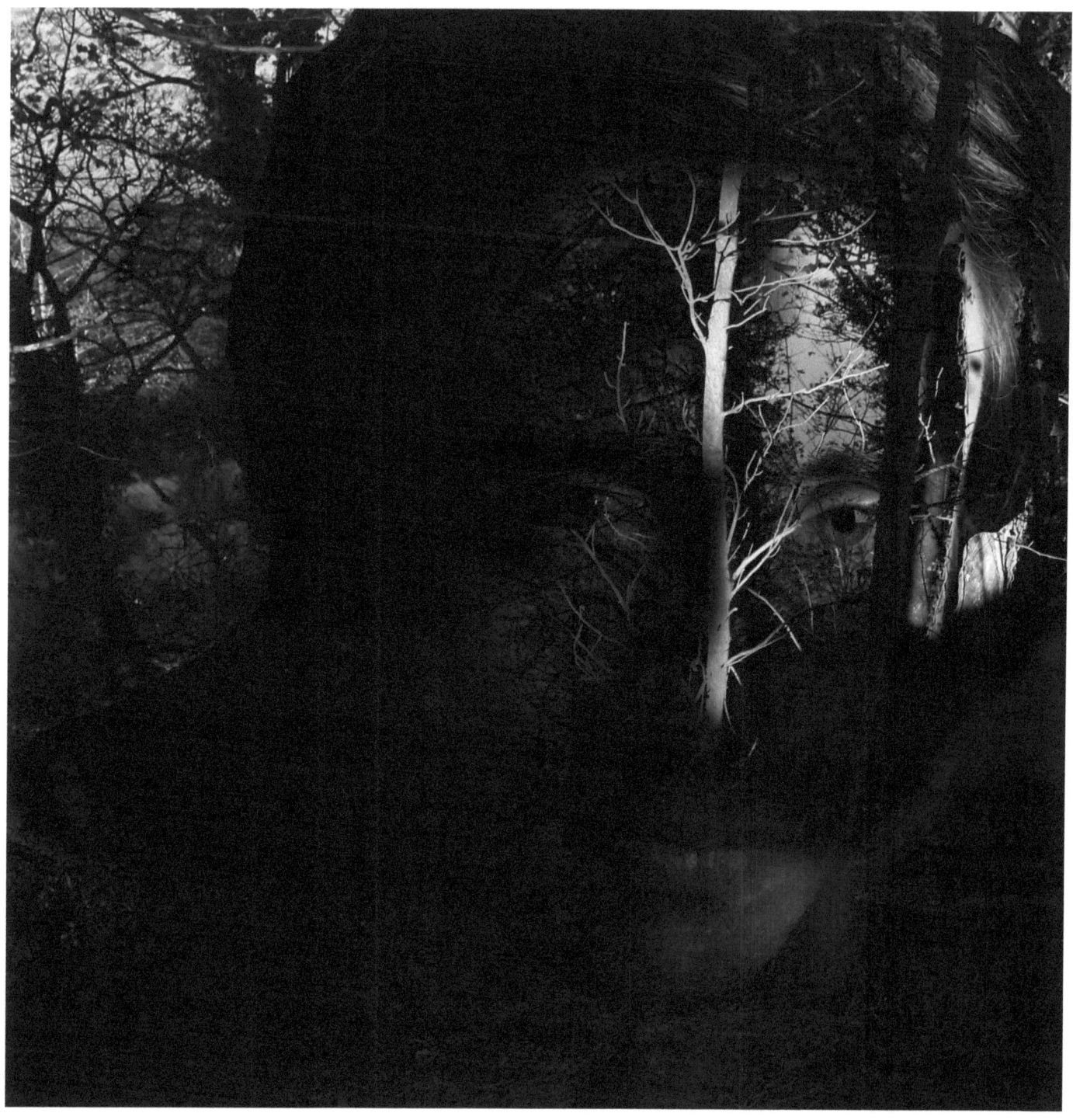

Late Autumn Gremlins

It's been... Hours. Probably.
One phone call, that's all.
I took off.
Just left.

Over two fields, sidestepping dung
and that one very angry ram,
I pushed on through between
pastoral cracks
and back
to nature, I guess.

Late Autumn gremlins are biting
through this thin jacket,
my shoes are clotted thick with mud
and I am pretty certain I have twigs in my hair.
I want to melt into the thick leafy mush at my feet.

This is the third.
Third time I called it off.
I always run here.
Cut through the trees,
and the ocean of bluebells in Spring,
back to the place where two streams meet
and the river chatters louder, more happily.
Greets me, every time.

You can't have me here. I think that's why.
Urban sprawls, they can belong to a person.
Delicate saplings, angry squirrels and decomposing logs?
They don't really give a damn if you stake a claim.
They just are.
I can show off my vibrancy, like a carpet of wildflowers,
or be proud and stalwart like a thick-trunked oak.
Wild just is. I can be like that.

No fourth chances.

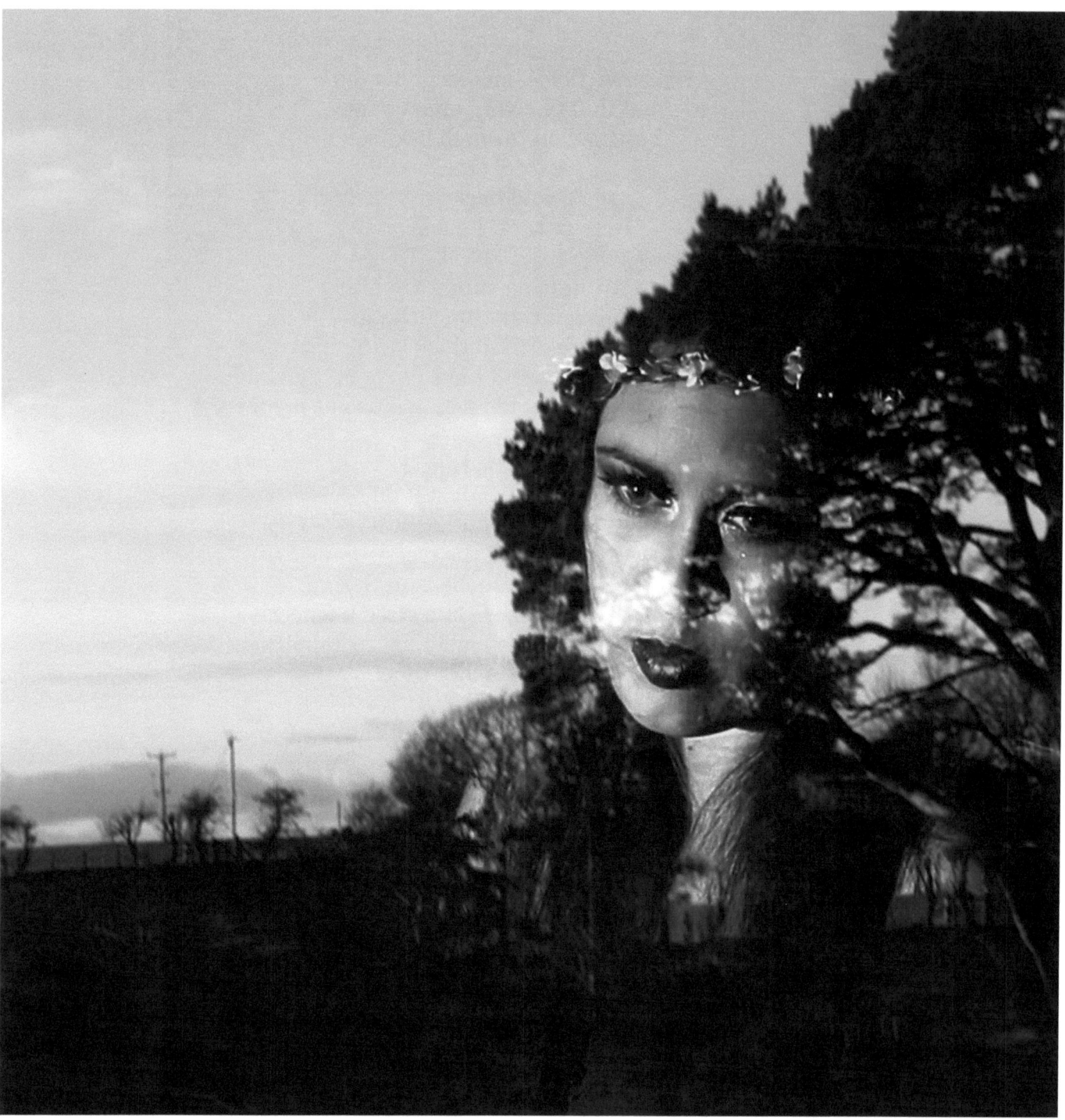

Ghosting

There was something here once.
A connection.
I'd walk down the path, between the feather greens
tickling the cloud-spotted sky.
My feet would hit the sand
and
I was home.
Grounded. Safe.

Now I smell stinking bladderwrack and pick up discarded
plastic.
Where did my magic go?
I ghost along this shore, skim pebbles across the waves
and try to catch crabs in the pools.
I can't bring it back.

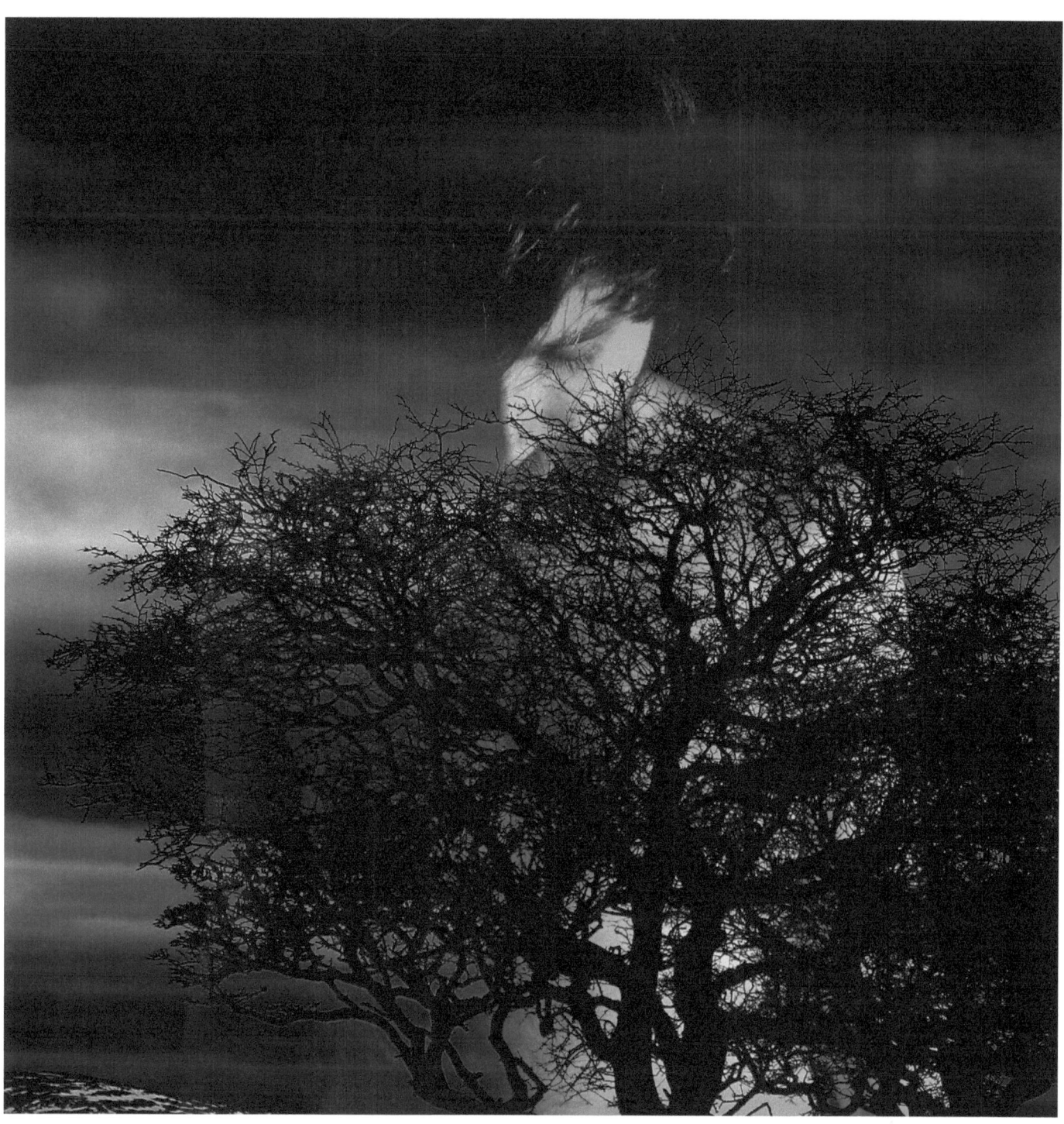

Grounding

Thick night, beneath bright stars,
Watching the fire burning
and fireflies waltzing
and waltzing
in the quiet.

It's resounding. Or almost.
A thrum here, a buzz there.
Rustles through the brush.
Whispers of life.

Breathe.
Repeat.
Breathe.
Restore. Replenish.

A sudden flurry. Wingbeats,
and white soaring
out of the sky.

Stretching out,
pushing the air
with my fingertips.
Feeling damp grass
beneath my toes.
Grounding.

Clouds roll in.
A tint of orange behind grey.
Rain pit-pats on the tents.
Stillness.
Back to me.
Find the centre.
Breathe.

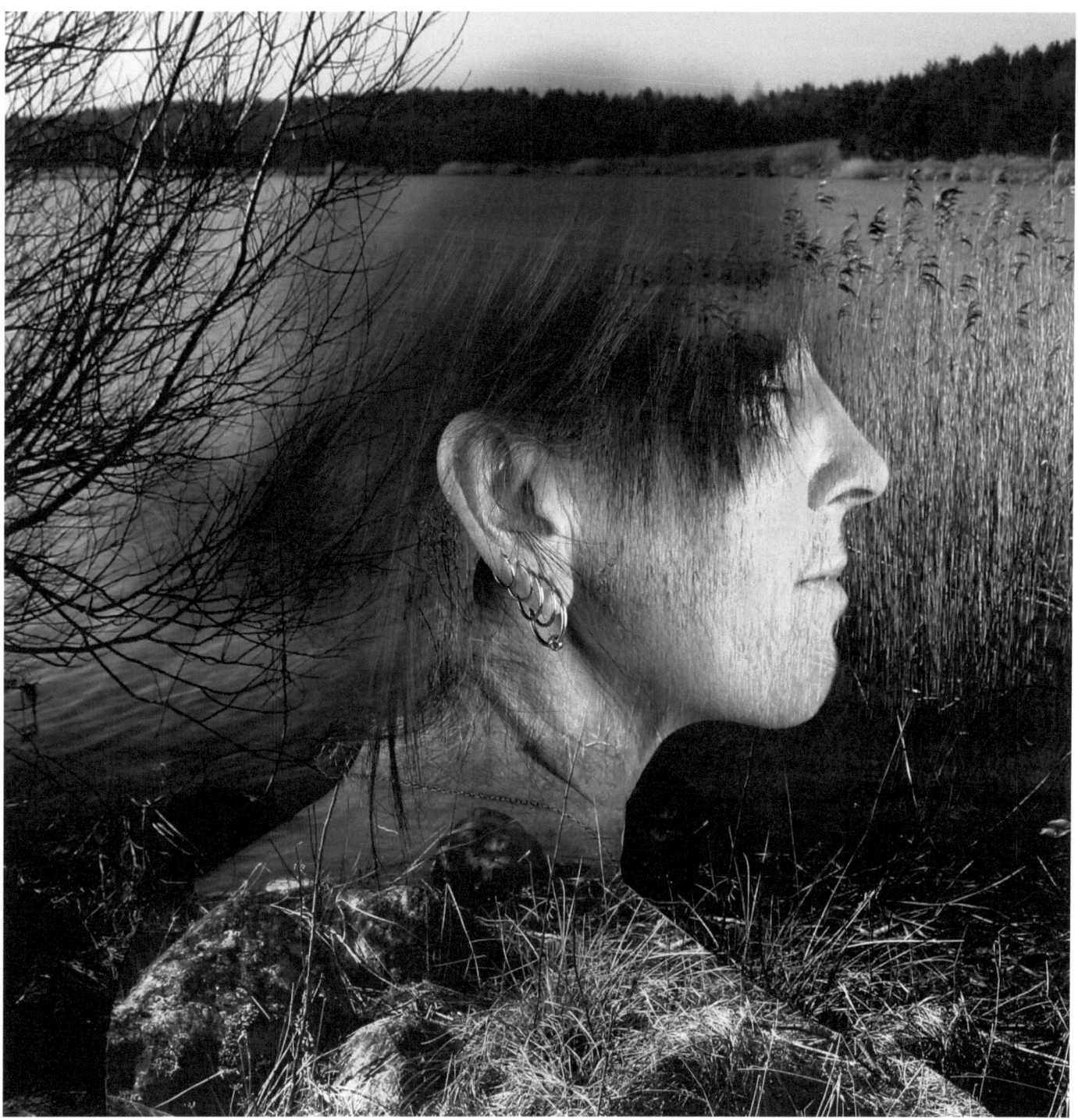

Driftwood by the Shore

Oh, to walk across your surface,
to run away,
skip over ripples
like a pebble skimmed.

You have no care
for our idle stresses.
our angers and passions
are driftwood by the shore.

Your depth without worry,
and movement without thought
blessed with just being no troubles to have been wrought.

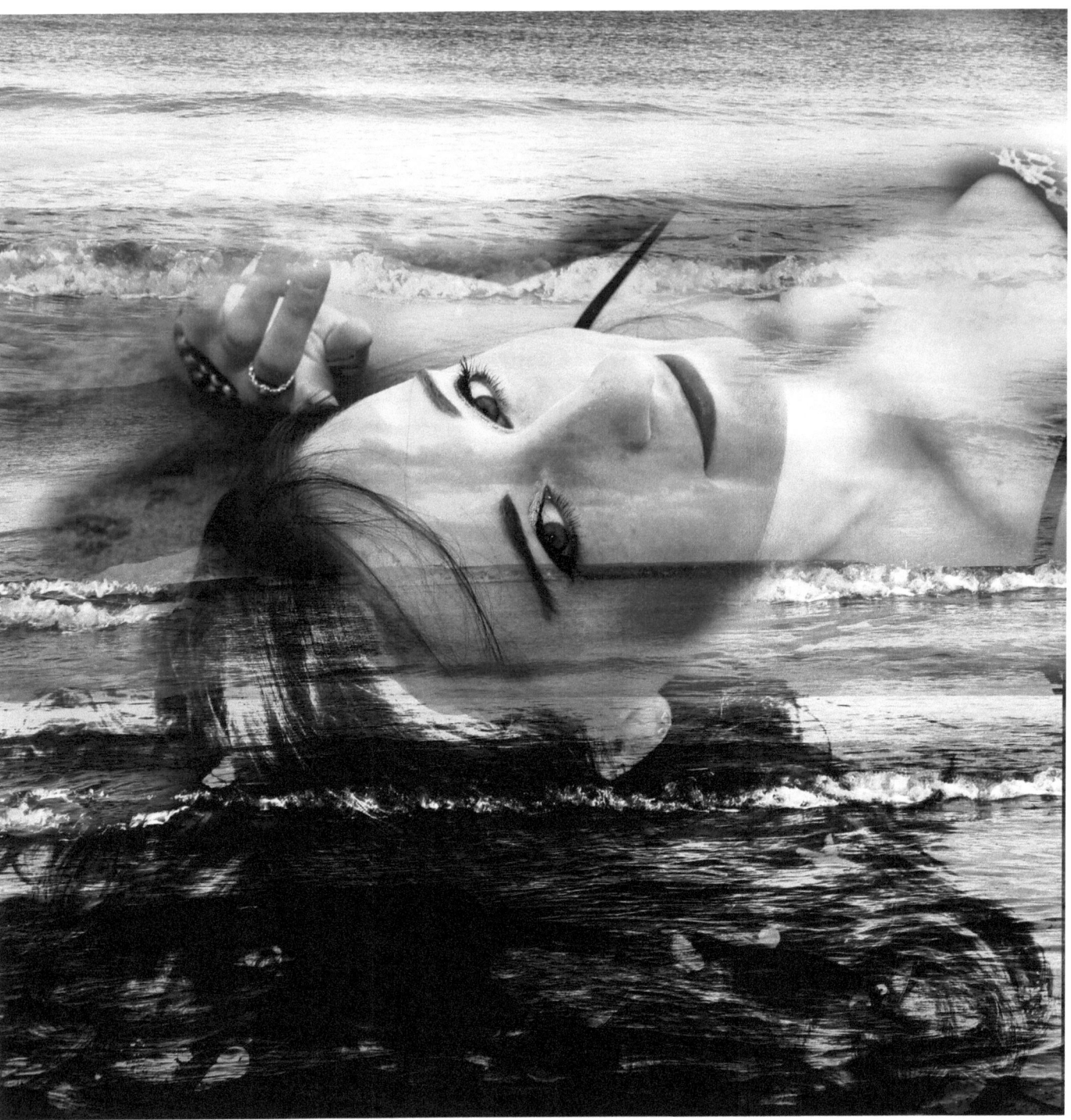

Queens Upon the Rolling Waves

They talk of nereids,
spirits of the sea,
queens upon the rolling waves
and residing deep beneath.
Or perhaps they speak of mermaids,
and sirens with their song.
What is it of a woman,
that casts her to the oceans
with fish to swim among?

Is it that you cannot fathom me,
my sublimity is too great?
Or perhaps you can't be bothered
and perhaps I shouldn't wait.
You say I'm like the waters
that push against the land?
Then do not deny my power,
for this I shall not stand.

I am a force of nature,
one to erode the walls.
A thing you cannot compare me to,
and reduce me all the same.
So watch me as I rise,
if a compliment is your intent.
But the sea does not back down,
just as I will not relent.

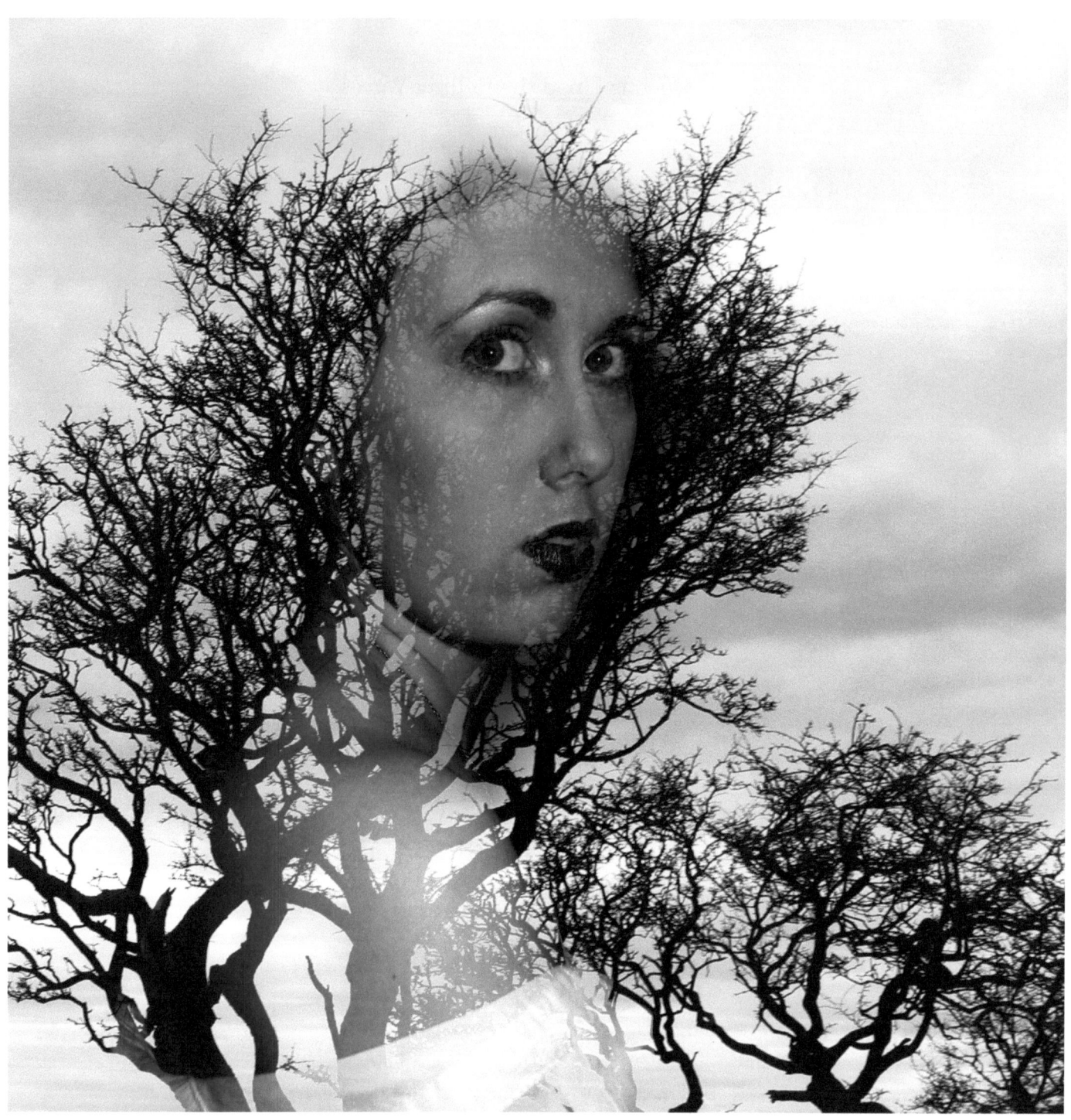

<u>Darling</u>

Riviera. I was promised *Riviera*.
This. This is just *a river*.
Darling, I don't do this.
I don't do camping.
I don't.
I won't.
…Fine.

Am I supposed to find the time to say.
that this is all beautiful, in every way?
Darling, I don't do that.

Fireflies glow at night, and they dance above the river.
Ooh yes. Doesn't *that* set a girl's heart a-quiver?
Darling, that was sarcasm.

Three mosquito bites. A wasp sting. Yesterday, a fly landed
on my tongue.
I don't have a rhyme. It was disgusting.

Some of us aren't cut out for this, okay? I'm not a
Wordsworth.
I see flowers and think, 'that's nice, leave it there. In the
earth.'
Darling, I really did try.

Riviera next month?
You mean it?
I suppose I can find a way to make this bearable.
Dominion over earth I suppose.
Darling, thank you.

A crow stole my favourite hat.
Darling, I am going home.

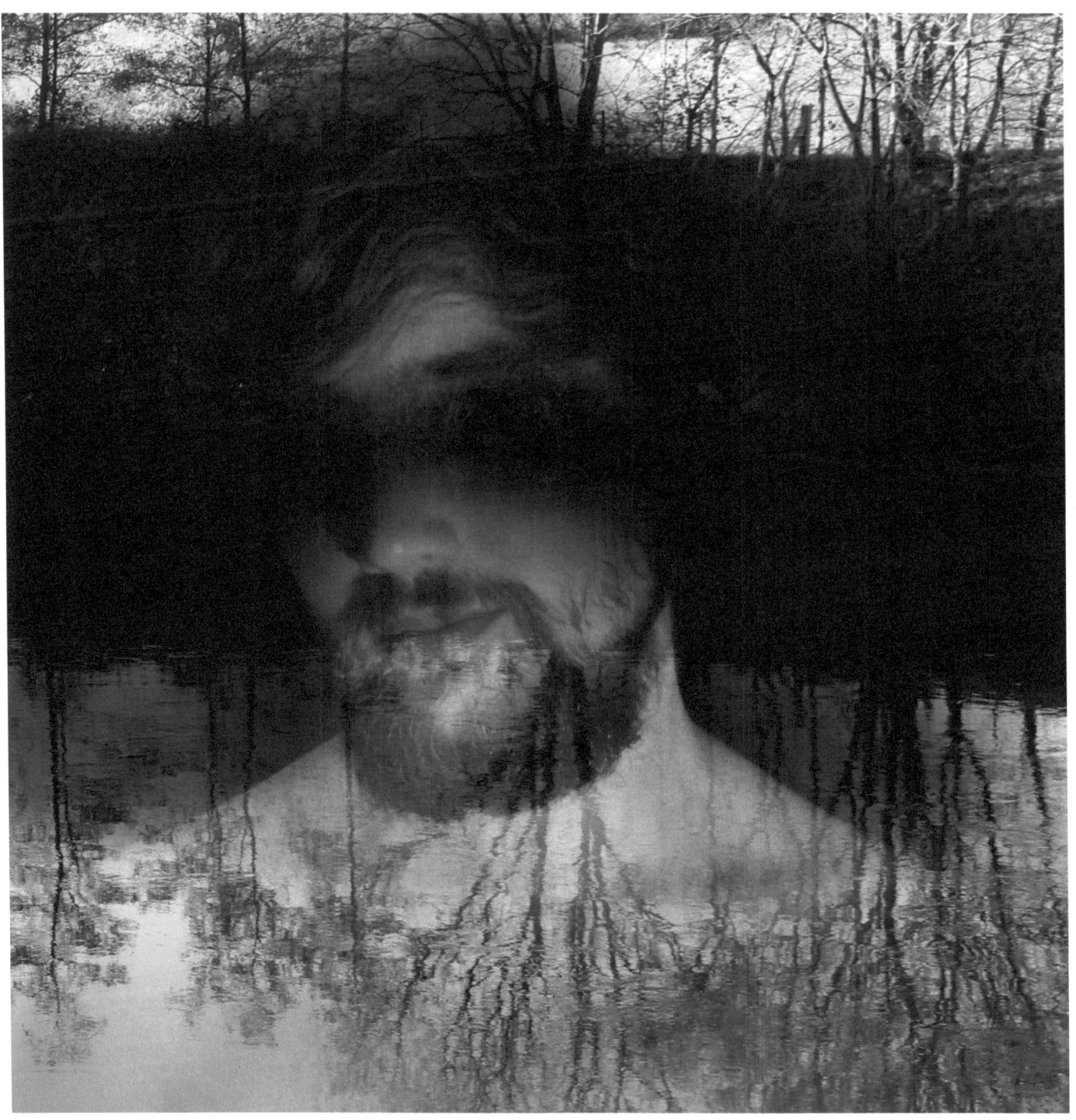

Unburden

Gurgle.
Gurgle.
Gurgle.
My mind trickles back and forth from focus
with the river's flow.

I can unburden in nature, my thoughts
worries
and perplexities
just wash
away
downstream.

A cleansing exercise. Renewal.
From river to sea,
to rain and nourishment.
And so the same for me.
Fears swim away on the current, dispersing until
they no longer matter.

And then I'm back. Tick-tick-ticking away,
every over analysis once more wildly and immediately
pertinent and insistent and-

Like fish in the water, let it writhe away.
Like water from the sky, be refreshed.
Learn and grow. Breathe out, slow.

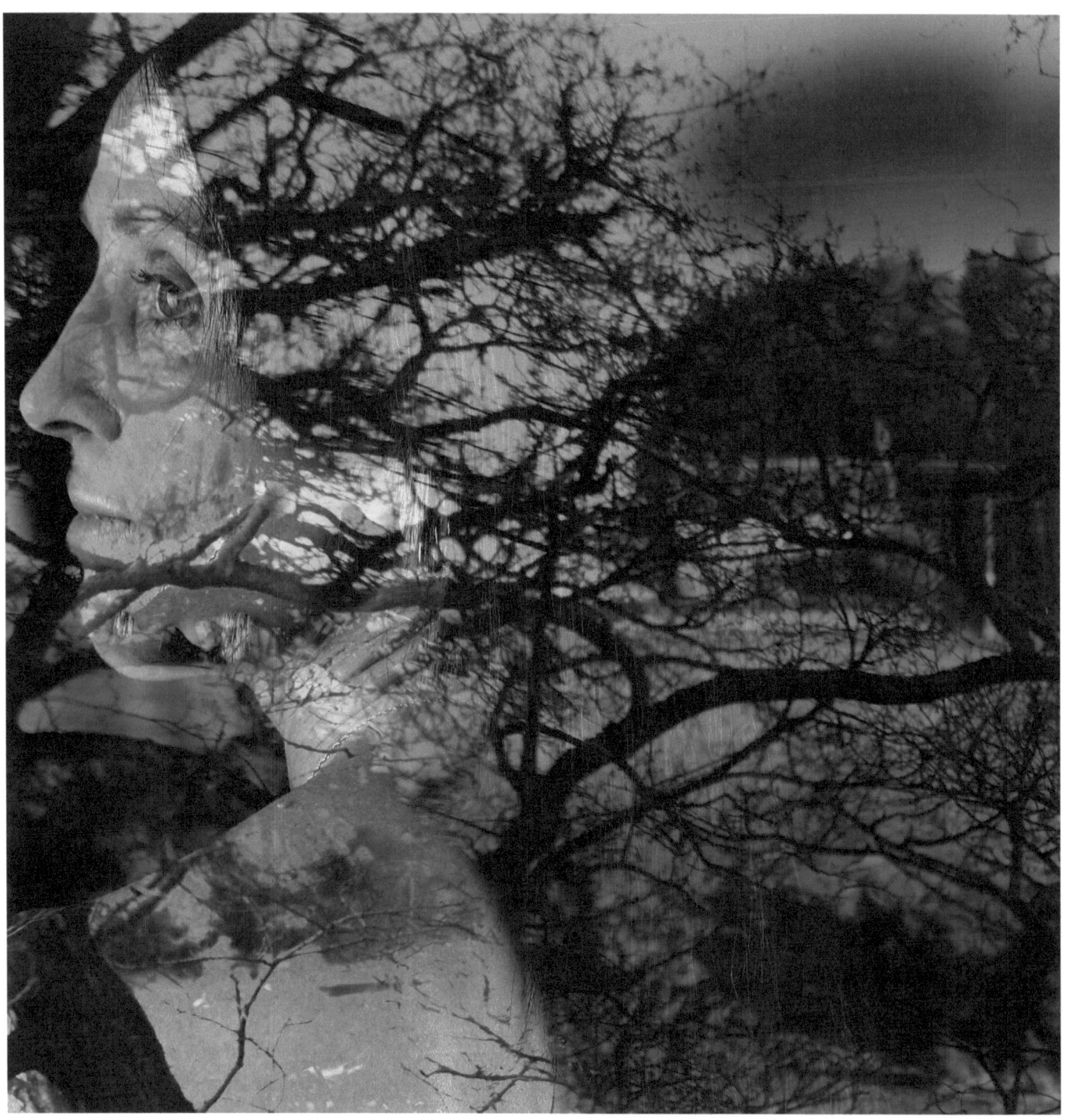

Pretty Stain

Castle to forest and river to town,
you go under moonlight,
around and around.
I've wished to ask,
so many times,
why you are so sad,
why your hair is a tangle
and why your dress
is
stained?

Here where we lay, and here where we loved.
The forest and the stream,
That Spring like a dream.
My dress from the fair,
The sweet-scented air.
We fall over, and tumble
And lose all our grace.
Then you hold my hand,
And you kiss my face.

You sit amongst the grass, in the clearing.
You look up. Left, then right.
Your hair is streaked silver now.
Mushrooms circle your feet and a
fallen tree rots into memory
Why are you crying,
why are you sad,
why is your hair a tangle,
and your dress
stained.
Again.

An arrow shakes the branches.
Green mottled red.
The spatters, on my chest, as you bled your
goodbye.
A stain for my pretty white dress.

The trees all removed,
your hair has turned grey.
You still returned.
You still returned today.
Why are your eyes lined so deep?
Where is your laughter?
Why are you crying?
Why is your hair a tangle?
Why
is
your
dress
still
stained?
Why are you crying?
'Why are you crying?'

His obsession unending.
Tainted longing, unrestrained wanting.
'Why are you crying?'
I shall not anymore.
Steel flash,
and a pretty red stain,
to mottle the grass.

www.ingramcontent.com/pod-product-compliance
Lightning Source LLC
Chambersburg PA
CBHW050907180526
45159CB00007B/2820